READ THIS
IF YOU WANT
TO TAKE GREAT
PHOTOGRAPHS.

First published in Great Britain in 2014 by Laurence King Publishing,
an imprint of The Orion Publishing Group Ltd, Carmelite House,
50 Victoria Embankment, London EC4Y 0DZ

An Hachette UK Company

19

A catalogue record for this book is available from the British Library.
ISBN: 978-1-78067-335-6

Design: The Urban Ant
Picture research: Peter Kent
Printed in China by Wing King Tong Offset Printing Co. Ltd.

www.laurenceking.com
www.orionbooks.co.uk

READ THIS IF YOU WANT TO TAKE GREAT PHOTOGRAPHS.

HENRY CARROLL

LAURENCE KING

Start by ignoring everything

Look, here's a drawing of your camera:

OK, so your camera doesn't look much like this one, but they both work in exactly the same way. Yours just looks more complicated.

A lot of new stuff has been added to cameras over the years. Some of these additions are quite handy, but a lot of them aren't. This book will teach you about the handy ones – the ones that actually work and give you all the creative freedom you need to take great photographs.

This isn't a textbook and I'm not going to use graphs and camera-club jargon to explain the fundamentals of photography. You don't need to know all that. In fact, when you're starting out, it only gets in the way and stops you being creative.

Instead, this book contains the work of inspirational photographers past and present. Through looking at their pictures you'll understand their ideas and techniques and learn how to put them into practice yourself.

You'll see that taking great pictures is less about technical knowhow and much more about mastering that most valuable piece of kit – your eyes.

But for now, try to remember that no matter how unnerving all the buttons, symbols and dials may seem, your camera is just a box with a hole in it. Whether it cost a few pennies or a few grand, that's all there is to it.

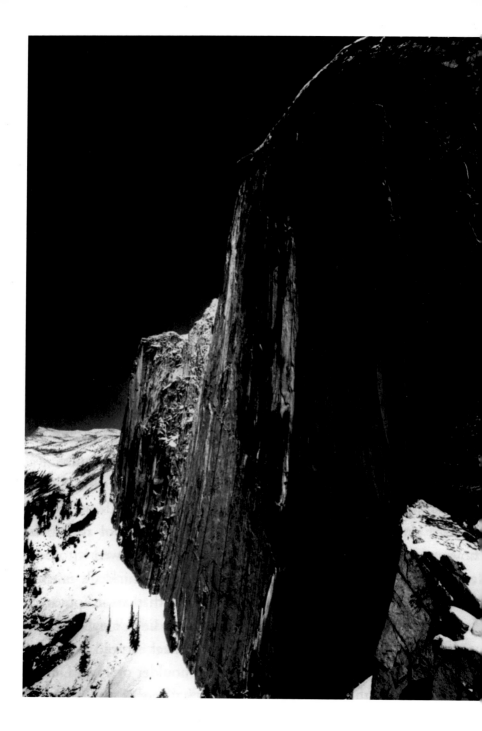

'You don't take a photograph, you make it'
(Ansel Adams)

There are 50 different photographers featured in this book. They're a mixed bunch, each with their own styles, interests and ways of doing things. Put them in a room together and it might get heated.

But, eclectic as they are, there's something they all have in common. It's their shared appreciation for one of the most important aspects of photography – composition.

Think of composition as the foundations of your image. And just like those of a building, foundations need to be strong.

Composition is all about how you choose to order the visual elements in your picture. It's slippery and subjective, and often something you have to feel rather than calculate. But don't let this talk of feeling make you nervous, as I'm about to show you some fundamental techniques to help get you started.

These techniques are the ones that great photographers use time and time again. They're also the ones that will instantly make your pictures come alive.

COMPOSITION

Monolith, The Face of Half Dome,
Yosemite National Park, California
Ansel Adams
1927

Look for the leading lines

For other examples:

Alkan Hassan p. 21
Luca Campigotto p. 38
Joel Sternfeld p. 68
Jeanloup Sieff p. 88

Great compositions take you on a journey. Your eyes are guided around the image on a specific path, leading to where the photographer wants to take you.

Here, Henri Cartier-Bresson has taken a simple scene and created something beautiful. Instantly the strong, downward point of view makes us feel like we're falling into the composition. Soon our eyes latch onto the foreground railings and descend down the steps. As the railings bend to the left, the kerb becomes more dominant. Only then do we arc around to reach the subject – a man racing past on a bike.

This tightly controlled visual journey is called a 'leading line' and photographers love them.

Use leading lines to give your composition structure and draw the viewer to key elements.

One main leading line is often all you need and they're at their most powerful when they sweep in from the edge of the frame.

If you keep your eyes peeled you'll find leading lines everywhere, from the converging rails of a train track, to the branch of a tree or the cracks in a rock face – and don't be shy about making these lines very overt in your image.

In this case, Cartier-Bresson makes our eyes travel in a slingshot motion around the image to heighten its very essence – movement.

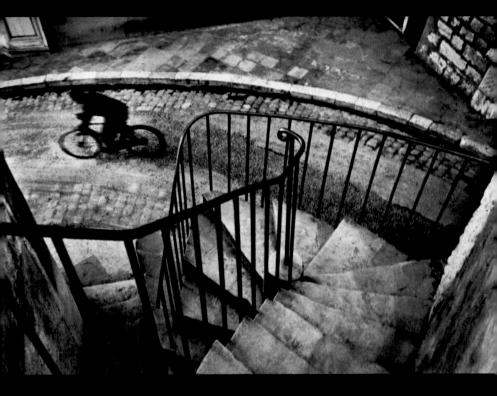

The Var department.
Hyères. France
Henri Cartier-Bresson
1932

The shape of things

It's not just the lines in your image that dictate how our eyes move across it. The shape (or format) is just as important.

Horizontal pictures (or landscape format) encourage our eyes to move from side to side. Vertical pictures (or portrait format) make them move up and down.

Choosing the format has nothing to do with whether you're shooting landscapes or portraits. Instead, try to match the format of your picture to the dominant lines – or natural flow – of your subject. This means the shape of your picture and the subject matter will work together to guide the eye in one clear direction.

In this photograph by Marc Asnin the landscape format prompts our eyes to glide from left to right along the undulating line of heads. It's a busy scene, but the landscape format creates order by drawing out this leading line, which in turn communicates the acute sense of drama.

Look at the Ansel Adams image on page 8 and see how the portrait format accentuates the hanging weight of the monolithic rock face. The gravity of the lines works in tandem with the vertical shape of the image, making our eyes sink from top to bottom.

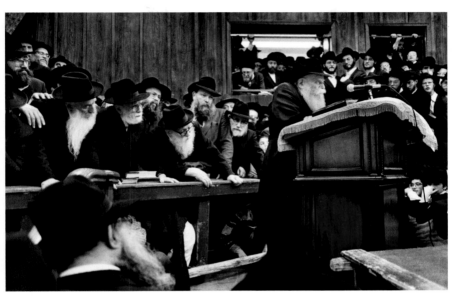

The Rebbe
Marc Asnin
1992

Think inside the box

For other examples:
Martin Parr p. 18
Ernst Haas p. 37
Denis Darzacq p. 53

Like the post-apocalyptic film *Mad Max*, in this image teenagers rule the world, running free across desert plains fuelled by one hedonistic fix after another.

Photographing during Nevada's Burning Man festival, Cristina Garcia Rodero finds order in an otherwise anarchic scene through the use of framing. Here, our eyes initially bypass the hoards occupying the van and hone in on the leaping figure framed by a hoop.

Framing draws attention to a particular part of your composition. It's especially handy if you're shooting a busy scene.

Look for doorways, windows and openings – anything that might help to focus attention on a particular part of your composition. But framing is a powerful tool, so don't just frame any old thing. Find subjects that are worth putting a frame around. Think of it as creating a photograph within your photograph.

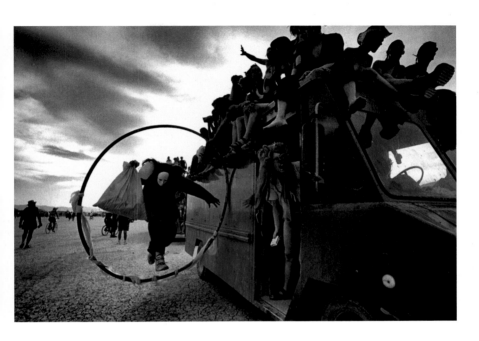

Burning Man Festival,
Black Rock City. Nevada, USA
Cristina Garcia Rodero
1999

The layered look

For other examples:
Henri Cartier-Bresson p. 11
Joel Sternfeld p. 68

Landscape photographers are especially picky. They don't simply plonk their tripods anywhere. They hunt around for just the right spot. And it's not a case of *around about here* will do, it's a case of *exactly* here.

In this image by Edward Burtynsky the subject is a rusting container ship. But the composition has a few more layers to it than that. Look at the textured mud in the very foreground, which leads us into the reflection and then up to the subject. This foreground mud isn't there by chance. Burtynsky positioned himself to make this an essential part of the composition. It's what's called 'foreground interest'.

Foregound interest offers the viewer a stepping stone into your image and heightens its sense of depth.

Here, without the foreground interest, our eyes would feel too separated from the middle distance and background, and the image would lose its sense of depth. Cover the foreground area with your hand and you're suddenly stranded, forced to make a visual leap of faith across a murky expanse of water.

When shooting landscapes, it's easy to fixate on the big vistas, but always keep an eye on what's going on immediately around you. Often what's right at your feet holds the key to a crafted composition.

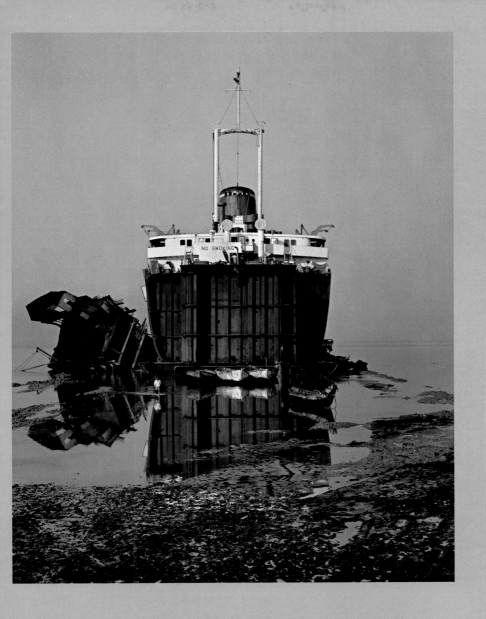

Shipbreaking #31,
Chittagong, Bangladesh
Edward Burtynsky
2001

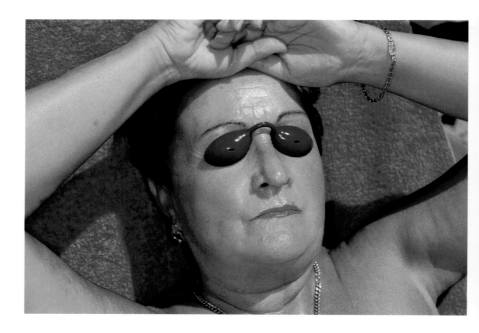

Benidorm, Spain
Martin Parr
1997

Get close.
And then get closer.

Risking thumps, shouts and dirty looks, Martin Parr is a photographer who often gets uncomfortably close to his subjects. By doing so, Parr draws our attention to the small but telling details, which would be lost in a wider composition.

Here, by getting in close and filling the frame with the subject, the photographer forces us to notice the subtleties that make this image so peculiar: the scarlet lipstick on those slightly pursed, dissatisfied lips; the gold jewellery; those oval goggles with the lizard-like eyeholes. All these details mean you can't help but form an opinion of this woman – welcome to Benidorm!

Very often, nothing kills an image more than keeping your distance.

By getting in close – really close – and filling the frame with your subject, you'll communicate that single, all-important observation that captured your interest in the first place.

So why not just stand further back and give the image a cheeky crop afterwards? Think of cropping as a fine tuner rather than a way of fundamentally altering your image. It's important that Parr puts himself in the line of fire to get the shot. If he didn't, his pictures would lose their humour and start to feel too underhand.

For other examples:
Shikhei Goh p. 98

It's a primal instinct

Few could argue with the simple beauty of symmetry. It's something that has universal appeal, satisfying our primal need for order.

Alkan Hassan instantly draws us into his composition through symmetry. The man is positioned right in the middle of the frame while the lines of the buildings draw our eyes into him like the triangle of a sealed envelope.

Symmetry isn't simply a case of composing your image like an ink blot. It's about creating an overall sense of harmony and balance.

The symmetry here reflects the state of mind of the subject. There's nothing anxious about him. Whatever or whoever he's waiting for, he seems totally calm and at peace with the world. It's an image of utter tranquillity in the built environment.

Placing your subject in the middle of the frame is a good way to create symmetry. Just be warned: there's a fine line between balance and boring. If everything is too perfectly mirrored, an image can feel a little soulless. Allow the human elements to creep in. The little things that draw our attention without upsetting the balance. Imagine this image without that bag – everything might start to feel a little too perfect. A little too phony.

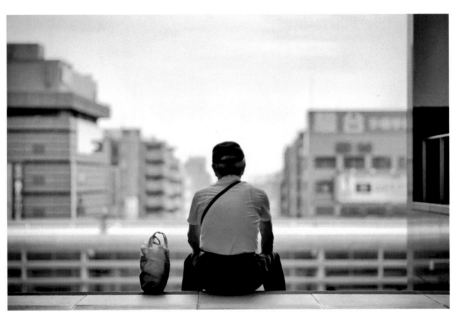

Above the City
Alkan Hassan
2010

Be offish

Like many, Guy Bourdin loves a good bottom. But rather than putting this one slap bang in the middle of the frame, here he's added to the eccentricity of the shot by positioning the subject off-centre. Even so, the image is still nicely balanced, or, to put it another way, it doesn't look 'wrong'.

That's because Bourdin has used the 'rule of thirds'. This means splitting your frame into three sections – either horizontally or vertically – and positioning your focal point in line with this imaginary grid.

If you don't want to centre your subject, the rule of thirds helps maintain balance.

Many photographers will spit at the mere sight of the rule of thirds because it can feel too calculated. That said, they're all secretly at it. Just use it as a rough guideline and be careful not to position your subject too near the edge of the frame, or only slightly off-centre, as this can look a little clumsy.

Charles Jourdan campaign
Guy Bourdin
Spring, 1979

42nd Street and Eighth Avenue
Lars Tunbjörk
1997

Make every inch count

I love this picture by Lars Tunbjörk. I love the fact that no single part is beautiful. The beauty comes from everything working together. Nothing is out of place. Nothing seems incidental.

You can't 'snap' pictures like this. They're the result of knowing exactly what's going on in every part of your frame.

When lining up your shot, it's your subtle movements that will make everything slot into place – *a little lower, a touch to the left, a couple of steps back*. These minor adjustments ensure the foreground fencepost is absolutely vertical. They mean the passing taxi is framed rather than cut in two. They make the vivid tapestry of colours balance each other, without anything becoming too overpowering. They ensure nothing is creeping into the frame that doesn't belong.

When composing your image avoid 'passive' areas that don't add much.

Just when you think you're ready to take your picture, pause for a moment and glance around your frame – is everything where it should be? Is the composition working as a whole? If you're not quite nailing it, change position – even very slightly – and keep an eye on how all the elements move around in relation to each other.

For other examples:
Marc Asnin p. 13
Lewis Baltz p. 27
Joel Sternfeld p. 68

Reducing it down

For other examples:
Guy Bourdin p. 23

This image doesn't have the busyness of the last. But even with all that space, none of it seems unnecessary. Everything is exactly where it should be. It has the same sense of cold order as the landscaped industrial park it depicts.

Here Lewis Baltz felt the visual weight of each element. He didn't just see a garage door surrounded by a brick wall and an area of tarmac. Instead he reduced everything down to two-dimensional shapes and tones.

Don't see the world as it is. See it as a photograph.

Notice how much 'heavier' the dark ground seems compared to the light wall, and how this has influenced the amount of space Baltz has given them in the frame. See how the grey of the garage door is counterbalanced by the diamond of white cut into the tarmac. See how the space between all of these elements, and their position in relation to the edge of the frame, creates absolute equilibrium.

Feeling the visual weight of your scene is a complicated balancing act, but your eyes are already pretty effective weighing scales. You measure visual weight when deciding where to hang a picture on a wall or when arranging food on a plate. All you have to do now is apply this already honed skill to your photography.

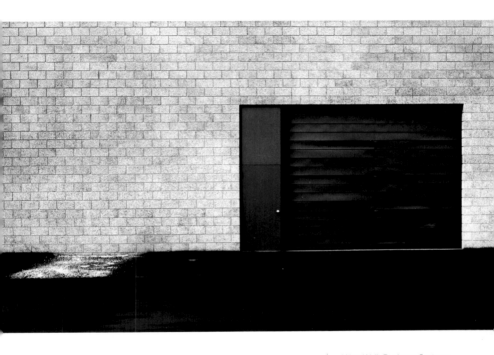

West Wall, Business Systems
Division, Pertec, 1881 Langley,
Costa Mesa
from 'New Industrial Parks'
Lewis Baltz
1974

Throw the rule book out the window

Everything about this image by Bill Brandt is so wrong.

First, our eyes are pulled out of the image by the path on the right. Then there's that off-kilter lamppost, awkwardly making contact with the very top of the frame. And look how the subject – the painter Francis Bacon – is positioned to the extreme left, his gaze brutally cut short by the edge of the frame. Add a horizon line that cuts right through the subject's head and you've got an altogether uncomfortable composition, riddled with tension and anxiety.

Tension and anxiety. Actually, that sounds a lot like Bacon's paintings. On second thoughts, everything about this image is so right!

Good photographs conform to the rules. Really great photographs often break them.

While compositional techniques like leading lines, the rule of thirds, framing, and all the rest serve as essential building blocks, too much of that can make your photographs feel a bit safe and predictable.

So rather than making sure everything 'conforms', concentrate on creating compositions that capture the essence of your subject. This is a picture of a man who painted deformed heads, screaming popes and animal carcasses. Somehow, I don't think the rule of thirds would've done the job.

Now go out and practise

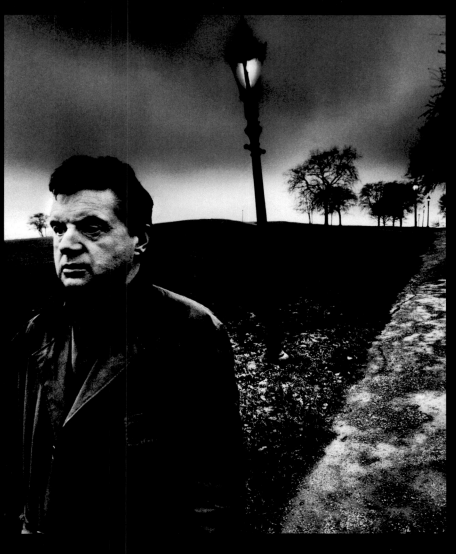

Francis Bacon, Primrose Hill
Bill Brandt
1963

SHUTTER SPEED/MOVEMENT

SLOW — FAST

| 1" | 1/2 | 1/4 | 1/8 | 1/15 | 1/30 | 1/60 | 1/125 | 1/250 | 1/500 | 1/1000 | 1/2000 |

More light enters
Use with narrow aperture
Blur movement

Any slower and
risk camera shake

Less light enters
Use with a wider aperture
Freeze movement

APERTURE/FOCUS

WIDE — NARROW

| ƒ/2.8 | ƒ/4 | ƒ/5.6 | ƒ/8 | ƒ/11 | ƒ/16 | ƒ/22 |

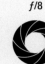

More light enters
Use with faster shutter speed
Shallow depth of field / less in focus

Less light enters
Use with slower shutter speed
Deeper depth of field / more in focus

ISO/SENSITIVITY

LOW — HIGH

100 ——— 200 ——— 400 ——— 800 ——— 1600

Less sensitive to light
Use in brighter conditions
Less image noise

Suitable for an
overcast day

More sensitive to light
Use in darker conditions
More image noise

EXPOSURE COMPENSATION

DARKER (−) — (+) BRIGHTER

| -3 | I | I | -2 | I | I | -1 | I | I | 0 | I | I | +1 | I | I | +2 | I | I | +3 |

Make image darker
Less detail in shadows /
More in highlights

Always reset
to zero

Make image brighter
More detail in shadows /
Less in highlights

(Some cameras place + on the left and − on the right)

Seeing through the science

When you take a picture, you control how much light enters the camera. Let too much light flood in and you'll overexpose your image, meaning it will be too bright. Don't let enough light in, and you'll underexpose your image, meaning it will be too dark.

This balancing act is called exposure and it's a case of juggling your shutter speed, aperture and ISO (International Organization for Standardization). This happy trio is inseparable. Each member is different. Each has its own job. And that's exactly why they rely on each other so much.

SHUTTER SPEED controls the length of time that light enters your camera

APERTURE controls how much light enters your camera.

ISO controls how sensitive your camera is to light.

Now you might think that exposure all seems a little sciency. On first impressions it is. But once you get to grips with a few fundamentals you'll soon see that adjusting your shutter speed, aperture and ISO is just as much an exercise in creativity as it is in controlling light. And this term 'correct exposure', well, that's just a matter of opinion.

But before we delve into the fundamentals of exposure, let's demystify a few things about camera modes.

The good, the bad and the ugly

Your camera probably offers you anything between eight to fifteen shooting modes, right? You might think that having so many different modes is a bonus, but the truth is you'll never need to use most of them.

THE GOOD

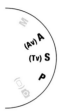

P, S (Tv) and **A (Av)** are the only modes you need to get familiar with to take great photographs. These are the good guys. They'll help you unlock your creativity and achieve the results you want. We'll get to know them better over the next few pages.

THE BAD

'Scene modes' – the modes represented by a picture, like this ⛰🌷 – are junk. These are factory presets, which adjust your camera's settings to shoot a particular subject in a particular way. But there's no single right way to photograph anything. That's why your own ideas and creative flair are so important. So, from now on, just try to pretend they're not there.

THE UGLY

The fully 'Auto' mode is for quick snapshots, which often turn out looking nothing like you intended. Think of this as the mode with no personality or imagination. Having said that, it's OK to set your camera to automatic – it's just that there's another mode that's far better than this one.

It's ok to 'P' in public

Manual – Goooood. Auto – Baaaaad

This is the deranged chant of camera-club traditionalists who think photographs taken using a manual setting are somehow more worthy. Don't listen to them.

When you're starting out, one of the best modes you'll ever use is P.

P stands for 'Posh Auto' or, more accurately, 'Program'. This is the mode to use if you want your camera to sort out all the technical number stuff for you so you can concentrate on honing your eye. And, unlike the fully 'Auto' mode, using **P** gives you a certain amount of all-important creative freedom.

Firstly, using **P** means your flash won't automatically fire. This is good, as your flash will more than likely ruin your shot. Secondly, you can change your ISO, which is something you definitely need to know about.

But before we learn about either of these things, it's time to introduce you to the first member of the exposure trio – shutter speed.

The bish, bash, bosh guide to shutter speed

When you take a photograph, your camera's shutter opens, letting in light. It stays open for a period of time (usually only a fraction of a second) and then closes, cutting off the light. This period of time is called the 'shutter speed'.

For reasons you'll soon see, sometimes you'll want to be in total control of your shutter speed. In these cases, the best mode to use is 'Shutter Priority', which is marked by **S** or **Tv**.

'Shutter Priority' allows you to change your shutter speed, while your camera kindly sorts out the correct corresponding aperture. But let's ignore aperture for now.

Here's how to change your shutter speed:

BISH Select 'Shutter Priority'. Most cameras have a mode dial. For those that don't, you'll be able to access your modes through the menu.

BASH Lightly tap the shutter release button to make your camera come to life. This is the button you press to take pictures.

BOSH Scroll one way to make your shutter speed faster. Scroll the other way to make it slower.

As you scroll, you'll see numbers from this scale:

SLOW				**SHUTTER SPEED**/MOVEMENT						FAST
1"	1/2	1/4	1/8	1/15	1/30	1/60	1/125	1/250	1/500	1/1000 1/2000

Cameras show shutter speed either as a fraction, for example **1/500**, or a number, for example **500**. Either way, this indicates a shutter speed that is a fraction of one second. So **1/500** (or **500**) means your shutter will open for a mere one five hundredth of a second. That's fast.

If you see a double quotation mark after a number, for example, **2"**, this means your shutter speed is no longer fractions of a second, but whole seconds. So **2"** means your shutter will open for two seconds. In photography, that's an eternity.

Generally, when it's darker you have to use slower shutter speeds and when it's brighter you have to use faster shutter speeds. This is because shutter speed acts like a timer, which controls the length of time light enters the camera. So if it's dark you'll need to allow light to enter for longer.

Now, let's put exposure aside for a moment because this is where it gets really sexy. Shutter speed also creates two very distinctive visual effects in your image, and it's all about photographing movement.

The beauty of blur

For other examples:
Luca Campigotto p. 38

Slow shutter speeds blur movement. This is because the shutter stays open for longer, giving objects more time to move while the picture is being exposed.

Here Ernst Haas uses a slow shutter speed of perhaps three seconds to surround choreographer George Balanchine in a beautifully rhythmic blur. As the dancers pirouette around the frame, the traces of their movements contrast with the stillness of Balanchine, who remains motionless, looking on intently.

To blur your moving subject, select 'Shutter Priority' (S or Tv) and a slow shutter speed.

When shooting everyday subjects, such as people running and passing cars, you'll start to see obvious signs of blur at shutter speeds slower than about **1/60**. The slower you go, the greater the blur.

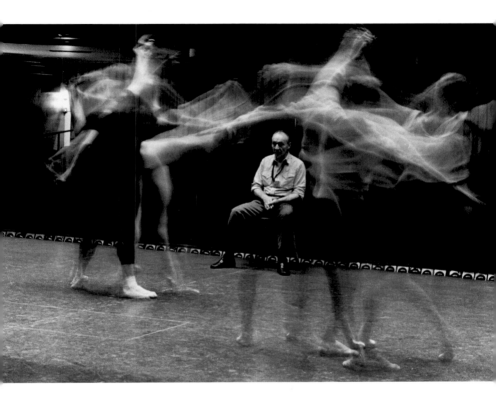

George Balanchine,
New York City Ballet
Ernst Haas
1960s

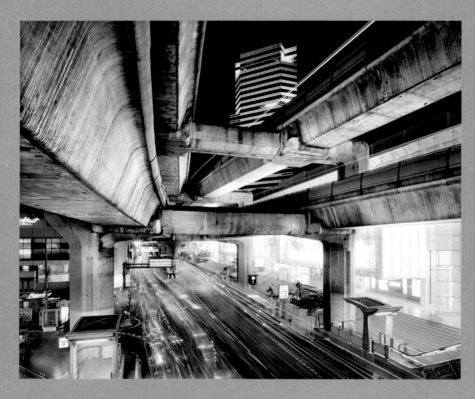

Bangkok from 'Cityscapes'
Luca Campigotto
2006

Light trails

Photographers have long been seduced by the luminous lure of cities after dark. As the sun goes down the lights come on, and what was nondescript during the day suddenly comes alive at night.

Here Luca Campigotto uses a slow shutter speed to transform a city street into an artery of red and white light. As the shutter has stayed open for a few seconds, the passing cars have become nothing more than long trails of brilliant light.

When shooting on slow shutter speeds, make sure your camera doesn't move. If it does, everything in your image will looked blurred. This is called 'camera shake'.

Here the only evidence of movement is the traffic, while the surrounding architecture has remained absolutely pin sharp. This is because Campigotto mounted his camera on a tripod to ensure that it didn't move during the exposure.

Camera shake caused by hand holding your camera is the most common cause of death for night shots. Some cameras offer 'Image Stabilization' **(IS)** or 'Vibration Reduction' **(VR)**. Switch this on and you'll find that you can hand hold your camera at slower shutter speeds without the risk of camera shake. But if you're going to use a shutter speed this slow, a tripod is the only cure.

The big freeze

For other examples:
Cristina Garcia Rodero p. 15
Denis Darzacq p. 53
Adam Pretty p. 59

Fast shutter speeds do the opposite to slow shutter speeds – they freeze movement.

For his series 'Blast', Naoya Hatakeyama uses a very fast shutter speed of **1/2000** to show the destructive effects of Japan's limestone mining on the landscape.

In this image, what would have been too fast to comprehend with the naked eye instead becomes a blowout of fantastic detail. Time is frozen as the reddish-brown debris hangs in mid-air against a beautiful blue sky. Here, the unease of destruction gives way to total seduction.

To freeze movement, use 'Shutter Priority' (S or Tv) and a fast shutter speed.

Subjects appear frozen when photographed with fast shutter speeds because, in the instant that the picture is taken, nothing in front of the camera has time to move. Generally shutter speeds of **1/125** and faster will start to freeze movement, such as people jumping and running water.

Remember, faster shutter speeds allow less light into the camera and if not enough light enters the camera, you'll underexpose your image. But there's a way around this. It's time to meet 'aperture'.

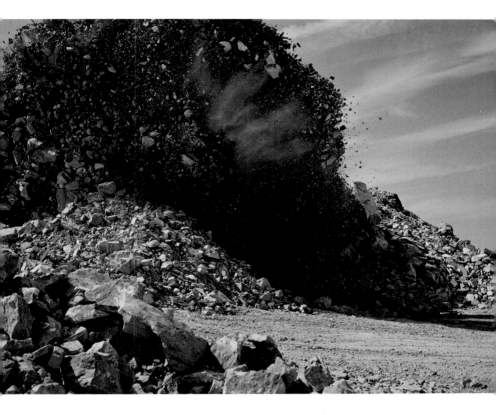

Blast #8316
Naoya Hatakeyama
1997

The bish, bash, bosh guide to aperture

The aperture is a hole in your lens that you can make smaller or larger to control how much light enters your camera. Aperture works in exactly the same way as the pupil in your eye, which dilates in darker conditions and contracts in brighter conditions.

As well as controlling the amount of light entering your camera, aperture creates a very distinctive visual effect, which we'll come to in a second. So just like shutter speed, which has a 'Shutter Priority' mode, aperture has its very own 'Aperture Priority' mode, which is **A** or **Av**.

The great thing about 'Aperture Priority' is that it allows you to change the aperture while your camera figures out the shutter speed.

Here's how to change your aperture:

BISH Select 'Aperture Priority'. Most cameras have a mode dial. For those that don't, you'll be able to access your modes through the menu.

BASH Lightly tap the shutter release button to make your camera come to life. This is the button you press to take pictures.

BOSH Scroll one way to make your aperture wider. Scroll the other way to make it narrower.

The exact size of the hole is measured in 'f-stops'. At first, f-stops can be a little confusing, as the higher the number, the narrower the hole, and vice versa:

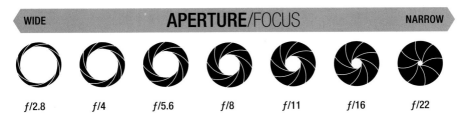

The aperture is in your lens, not your camera, so depending on your lens you might find that you have a different range of f-stops (or 'f-numbers', as they are also called).

Now here's the thing: as you change the aperture, notice what's happening to the shutter speed. It's changing too, right? When you select a wide aperture, such as *f/5.6*, the shutter speed is faster, and when you select a narrow aperture, such as *f/22*, it's slower.

This is because the camera is varying the shutter speed to compensate for the fact that you're letting in more or less light through the lens. It's a balancing act, and exactly the same thing was happening to the aperture when you were using 'Shutter Priority'.

But the plot thickens. Changing your aperture also radically alters the 'depth of field' in your image and I think this is something you're going to like.

Stand out by being shallow

For other examples:
Alkan Hassan p. 21
Slinkachu p. 46
Youngjun Koo p. 96

Here, Sebastião Salgado gives his subject a striking sculptural presence by making the lines of the man's body so clearly defined against an out-of-focus background. This effect is called a shallow depth of field. See how it causes us to be drawn to the intensity of the man's stare and his powerful, muscular frame covered with scarring and white ash.

To achieve a shallow depth of field select 'Aperture Priority' and a wide open aperture (low f-number).

By throwing an area of your image out of focus you're effectively getting rid of detail. This causes your subject to really stand out. As seen here, a shallow depth of field makes portraits particularly striking.

If you have a camera with an optical viewfinder (a DSLR for example), you won't see this effect when you're composing your picture. You'll only see it once you've taken the shot. If, however, you have a camera with an electronic viewfinder (most bridge and compact system cameras), you will see this effect through the viewfinder.

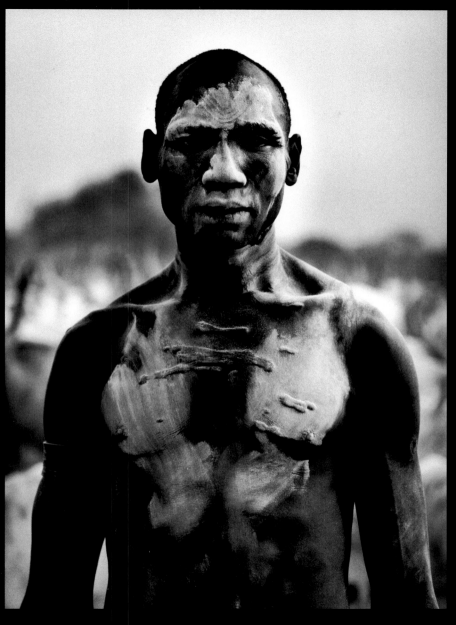

Dinka man, Southern Sudan
Sebastião Salgado
2006

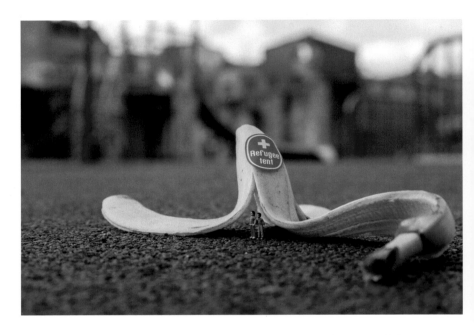

Hide and Seek
Slinkachu
2013

Compelling close-ups

Slinkachu is an artist who creates witty and sometimes tragic narratives by placing miniature figures in unexpected locations around the city. The set-ups are so tiny, most people pass them by without even noticing. This means his work relies on photography to bring it to a wider audience.

Depth of field is at its most shallow when shooting close-ups.

Here, Slinkachu has achieved such a shallow depth of field (a matter of millimetres) because he has used a wide aperture (low f-number) and is very close to his subject. He's also zoomed in a little, which helps to extenuate the effect of a shallow depth of field.

Focus is all about distance from the camera. Even though this is a close-up notice the physical depth that's very visible in the image. If you want to really see the effects of a shallow depth of field, make sure there's a good amount of distance behind or in front of your subject, otherwise there won't be anything to actually fall out of focus.

For other examples:
Shikhei Goh p. 98

Deep and meaningful

Here Richard Misrach photographs the scars left behind by military testing sites in the Nevada desert. Stretching into the distance, debris litters the landscape, like bones in an elephant graveyard, while in the foreground a bomb crater takes on the appearance of a vividly coloured hot spring. But rather than teaming with life, this toxic pool symbolizes only man-made death and destruction.

A narrow aperture (high f-number) causes everything from the foreground through to the background to be in focus.

This is an example of a deep depth of field and here it's helping to communicate the scale and detail of the landscape.

Landscape, and often portrait photography is generally less about capturing movement and far more about controlling your depth of field. For this reason, select 'Aperture Priority' so you're in control of your aperture and depth of field, while the camera worries about the shutter speed.

To help you remember the relationship between aperture and depth of field think: small f-number = small area of focus; big f-number = big area of focus.

Just remember, if you're using a very narrow aperture, your shutter speed will compensate by being slower, so use a tripod (or any stable surface) to avoid camera shake. There is, however, an alternative. It's time to meet the final member of the exposure trio.

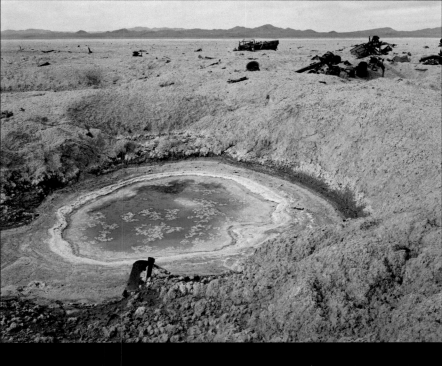

Bomb Crater and
Destroyed Convoy,
Bravo 20 Bombing
Range, Nevada
Richard Misrach

Your camera's sensitive side

ISO controls how sensitive your camera is to light. It works like this:

When it's dark you need to make the most of the limited light, so you increase the sensitivity of your camera by increasing your ISO. When it's bright, your camera doesn't need to be as sensitive, so you decrease the sensitivity of your camera by decreasing your ISO.

If your camera is more sensitive, light doesn't need to enter for so long, meaning you'll be able to use faster shutter speeds in low light. This will help to avoid camera shake.

To change your ISO, first make sure you're on one of the 'good' modes (see p. 32) then find your ISO setting. This will either be a button on your camera's body or an option in one of its menus. Find it and you'll see that your ISO scale looks something like this:

LOW	**ISO**/SENSITIVITY	HIGH

100	200	400	800	1600

(You might find that your ISO scale starts lower, goes higher or has more intervals.)

A good ISO for an overcast day is **400**. So when deciding on your ISO, start by asking yourself, 'is it brighter or darker than an overcast day?'

Always set your ISO first, as it affects what shutter speed and aperture you can use.

One of the great things about digital photography is that you can change your ISO from picture to picture. Go outdoors (brighter) and turn it down. Walk indoors (darker) and crank it up.

Just be warned, the higher the ISO, the more 'noisy' your image becomes. In extreme cases it's an effect not dissimilar to a photo taken on an early camera phone. Depending on your camera, it's something you might only start to notice when shooting on about **800** ISO and higher.

It's fair to say that ISO is the least glamorous of the exposure trio. But while it doesn't do anything creative in itself, as you're about to see, adjusting the sensitivity of your camera frees you up to achieve some really striking effects.

Your ticket to faster shutter speeds

For other examples:
Maciej Dakowicz p. 116

Now, you're going to find that you sometimes underexpose your image when trying to use fast shutter speeds, particularly in low light. This is where increasing your ISO is really helpful.

For his series 'Hyper', Denis Darzacq turns a supermarket into a stage for street dancers to perform. Here a dancer hangs suspended in the air, like something from a sci-fi movie.

Increasing your ISO is essential if you want to use fast shutter speeds in low light.

Even when you're not after such striking effects – perhaps you're simply wanting to avoid camera shake in low light – increasing your ISO will help you access faster shutter speeds. Remember, camera shake occurs at speeds slower than about **1/60** so nudge up your ISO just enough to tip you over that marker. Don't be tempted to just whack up your ISO as high as it will go or you'll risk unnecessary image noise.

Hyper No. 03
Denis Darzacq
2007

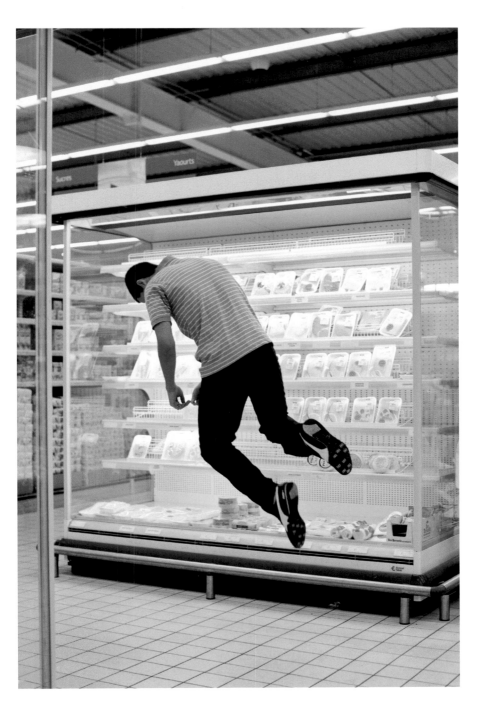

All good photographers use 'Manual', right?

Sit down. I'm about to tell you something that might come as a shock: shooting in 'Manual' (**M**) is a waste of time.

Still there? OK, I'll explain. Unlike 'Shutter Priority' and 'Aperture Priority', when using 'Manual' you're in control of shutter speed *and* aperture *and* ISO.

In 'Manual' your camera is still telling you what it thinks is the 'correct exposure', in exactly the same way that it does in every other mode. But instead of making the changes for you, you have to do it all yourself.

Often people use 'Manual' and simply adjust the shutter speed and aperture to match what their camera is telling them. By doing this they're effectively shooting in 'Program' (**P**), and taking a lot longer. Trust me, 'Manual' adds nothing to the picture!

When you're trying to get familiar with all the technical stuff, using 'Manual' slows you down, adds confusion and, worst of all, means you risk missing *the shot*.

That said, there is a situation in general day-to-day shooting when you could opt to use 'Manual'. It's when you want to override what your camera is telling you and intentionally under- or overexpose your picture. But rather than using 'Manual', I'm going to show you a much faster and easier method of getting the same result.

The alternative to 'Manual'

Meet 'Exposure Compensation'. This function allows you to make your entire image brighter or darker and looks something like this:

DARKER (–)	EXPOSURE COMPENSATION									(+) BRIGHTER								
-3			-2			-1			0			+1			+2			+3

On most cameras the exposure compensation button is marked by ☒ but some cameras have a dedicated dial instead. Scrolling towards **+** will set your camera to overexpose your photographs, meaning they'll be brighter. Scrolling towards **–** will set your camera to underexpose your photographs, meaning they'll be darker. Always remember to set your 'Exposure Compensation' back to **0** or you'll end up affecting all of your subsequent shots.

Intentionally over- or underexposing your photograph may seem an odd thing to do, but 'Exposure Compensation' is a function you'll find yourself using more than you would think.

In a nutshell if you photograph something very bright, like snow, you'll find that it looks quite grey or underexposed. Likewise, if you photograph something very dark, like the inside of a bar, you'll find it looks too bright or overexposed.

Exposure compensation overcomes this by allowing you to make your picture brighter (scroll towards the **+**) or darker (scroll towards the **–**).

Exposure compensation is also essential for a backlit subject. Let's look at a couple of examples.

Detail from the shadows

For other examples:
Alkan Hassan p. 21

Backlight is seductive and beautiful. But like many things seductive and beautiful, it has to be handled with care.

This poignant photograph by Jo Metson Scott shows a young ballerina taking a break from the rigours of practice at the National Youth Ballet. Pictured sitting on her own, deep in thought, she inspires empathy in anyone familiar with the pressures of performance. And it's that strong, overexposed daylight flooding in through the open window that seems to symbolize an escape for the girl and the choice between giving up and battling on.

Adding to the pull of this image is the fact that we can also see the young girl's face and her preoccupied expression. When shooting a backlit subject (someone in front of a window is a common example) they often become silhouetted and all facial detail is lost. This is because the light inside is much darker relative to the light outside.

To draw out detail in the shadows, use 'Exposure Compensation' and scroll towards the +.

By doing this you'll make your whole image brighter. This means the highlights might well blow out, but don't worry too much about this, as long as you can see the detail in your subject.

The precise amount to increase your exposure compensation by all depends on the specific lighting conditions. So the best way to get a feel for this is to grab your camera and give it a go yourself.

Laura Veazey in her Fox
Costume, National Youth Ballet
Jo Metson Scott
2010

Seductive silhouettes

For other examples:
Trent Parke p. 63

Unlike the previous image, where the photographer brought out the detail in the shadows, here Adam Pretty has thrown them into absolute blackness. The divers and surrounding architecture have become beautifully clean, abstract forms silhouetted against a richly textured sky.

To silhouette your backlit subject use 'Exposure Compensation' and scroll towards the –.

By doing this you'll underexpose your whole image, making the shadows darker while drawing out the detail in the highlights.

The more you underexpose your image, the darker the shadow areas will become and you'll start to see more detail in the highlights. But, again, don't take my word for it. Give it a go yourself.

Now go out and practise

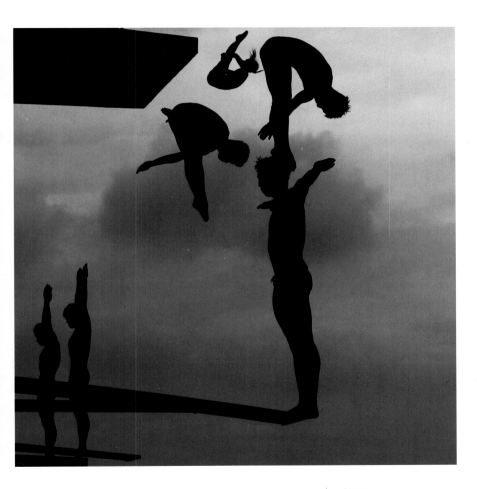

Divers
Adam Pretty
2011

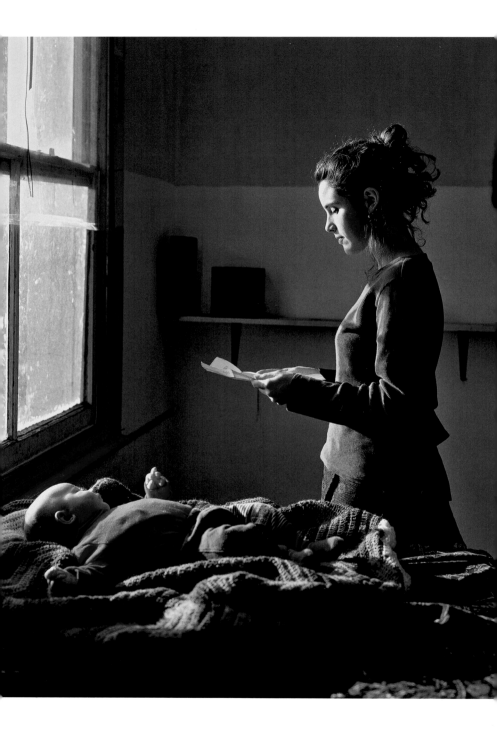

Light is your subject

LIGHT

You can't pick it up. You can't bump into it. You can't give it a cuddle – light is intangible. But to take great photographs you need to start thinking of light as an object – an object with the elusive power of a shapeshifter.

Everything is at the mercy of light. What's arresting one minute can leave no impression the next, simply because of a change in the light. The mundane can become beautiful and the beautiful, mundane. Just look at the light in this image by Tom Hunter. What mood is it creating?

Whether you have your camera with you or not, the only way to learn about light is to observe it constantly.

When you're sitting at your desk, walking down the street or driving your car, ask yourself, 'how is the light affecting the space and atmosphere around me?' Notice how it draws out textures, colour and detail. How it attracts your attention to a specific point within a scene. How it gives a space depth or makes it seem absolutely flat.

But with all its infinite forms and variations, light can be split into two fundamental types – hard and soft. Both have particular traits that affect the overall mood of your image. In this chapter we're going to start by comparing and contrasting some of the most common.

Woman Reading
Possession Order
Tom Hunter
1997

Hard light creates contrast

For other examples:
Lars Tunbjörk p. 24
Philip-Lorca diCorcia p. 91
René Burri p. 93

Hard light comes from one direction and is typical of a spotlight or bright sunshine. Due to its intensity, one of the most common traits of hard light is high contrast.

Trent Parke is a photographer who uses this kind of light to transform urban landscapes into something less familiar. Here the hard light cuts through the city forming an island of light where a couple stand seemingly marooned. But they're not without their supplies. Accompanying them in the highlights is everything they need, from a place to stay and somewhere to eat in the form of a motel and a fast food restaurant.

Hard light causes anything in its path to become a highlight, while everything else remains dark.

You can use the contrasts created by hard light to abstract or simplify your composition. That's exactly what's going on here. The shadows form large areas of black, which mask unnecessary detail. This, in turn, causes our eyes to be drawn to the highlights.

The unevenness of hard light makes it tricky to work with, as you will lose detail somewhere. This is another situation where exposure compensation helps. Scroll towards the + to bring out detail in the shadows and to the − to bring out the detail in the highlights.

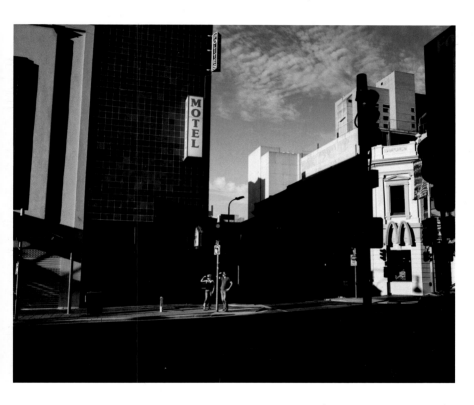

Heinley Street, Adelaide
Trent Parke
2006

Soft light is more even

For other examples:
Alkan Hassan p. 21
Sebastião Salgado p. 45
Richard Learoyd p. 73

If hard light packs a punch, soft light is more like a massage.

In Ryan McGinley's photograph a young man holds an alligator. But rather than being laden with drama, this image imbues a state of calm. His grip is more of an embrace and the black and white adds a touch of melancholy. But it's the soft light that's truly dictating the mood here.

Soft light is less intense meaning there isn't such a stark divide between the highlights and shadows.

Soft light still casts shadow as it very often comes from one direction, like hard light. But the shadows aren't nearly as dark and dramatic. Rather than being a void of black, detail is still very visible. This more even quality tends to make images feel 'slower' and more contemplative.

To soften light you need to diffuse it. In the studio this can be achieved by using what's called a 'soft box'. In more everyday conditions, where you have less control over the light, steer clear of any powerful directional light sources, such as spotlights, flash or bright, unobstructed sunshine.

Wes (Gator)
Ryan McGinley
2010

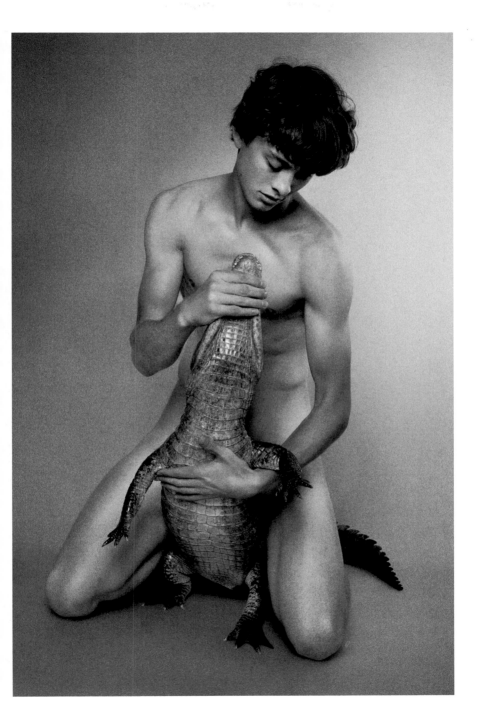

Hard light creates depth

For other examples:
Naoya Hatakeyama p. 41

Fay Godwin's black-and-white photographs celebrate the ever-changing light and landscape of the British Isles. Avoiding the sugar coated lies of picture postcards, Godwin's photographs instead show rural scenes interrupted by industry, both ancient and modern. Here a circle of standing stones seem engaged in a solemn meeting which has lasted three and a half thousand years.

Shadows tell us the whole truth about light. They show us where it's coming from and how intense it is. In this image taken just after a hailstorm, a sudden swath of hard sunlight breaks through the clouds, creating dark shadows with razor-sharp edges.

The strong, decisive shadows that go hand in hand with hard light create depth and three-dimensionality.

The shadows emphasize the jagged shape of the stones and accentuate their angles. It brings the stones to life and gives them more presence. We see that each is different; each has its own character and story to tell.

A few moments later the light would have changed and the shadows disappeared. But you don't need this kind of dramatic light to create captivating landscapes. In fact, as you'll see over the page, soft light does something completely different, but equally alluring.

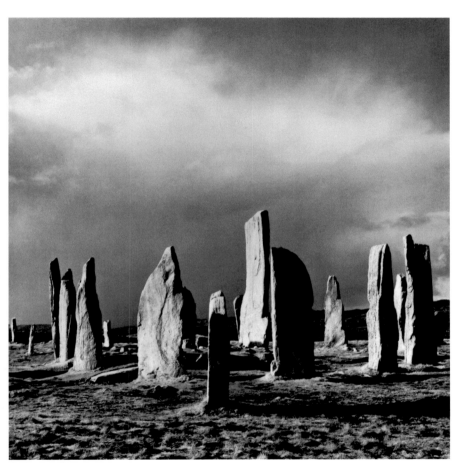

Callanish after Hailstorm, Lewis
Fay Godwin
1980

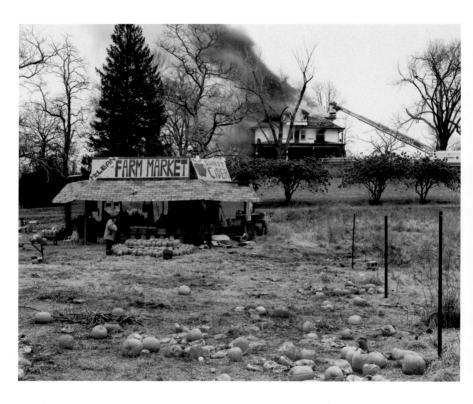

McLean, Virginia
Joel Sternfeld
December 1978

Soft light can be flat

A house burns in the distance while a fireman seems more concerned with choosing the right pumpkin than putting out the flames. In this photograph by Joel Sternfeld, what should be a dramatic scene instead has an intriguing sense of the everyday about it.

It's the soft or 'flat light' of an overcast day that helps remove any trace of drama here. This type of light is very low in contrast. It casts little or no shadow and makes everything in an image seem flatter. What we're left with here is a very matter-of-fact photograph, which draws us in through unanswered questions rather than instant gratification.

For other examples:
Richard Misrach p. 49

The blanket evenness of soft or flat light means that there are no dramatic shadows and highlights to create depth and draw the eye.

This evenness means your composition alone has to guide the viewer around your image. Here Sternfeld has used some classic compositional techniques to control the movement of our eye. I can spot three. If you need a clue, turn back to pages 10, 16 and 22.

Hard light is brutal

For other examples:
Martin Parr p. 18
Daido Moriyama p. 79
Philip-Lorca diCorcia p. 91

Lee Friedlander is a photographer addicted to the brutality of hard light. His compositions of city streets, roadside encounters, American landscapes and himself are often a disorientating onslaught of space and lines, carved up by the omnipotence of light and shadow.

This is one of Friedlander's most confrontational self-portraits. His finger presses down on that cable-release as though it were the trigger of a bomb. And look at the light. By facing into the light directly, Friedlander causes the shadow of the camera equipment to cut right through him, while the highlight draws us into his steely left eye. This, it's fair to say, is Friedlander on a bad day.

Hard light is dramatic. It creates cutthroat shadows and stark highlights, which are unforgiving and expose all.

If you're looking to flatter a subject then avoid hard light altogether. Friedlander isn't out to flatter. Instead, his photographic experiments with light, space and lines repackage the world and present us with something less familiar and far more arresting.

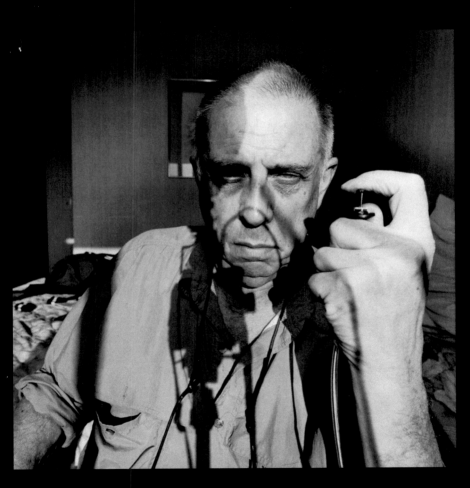

Oregon
Lee Friedlander
1997

Soft light is flattering

For other examples:
Sebastião Salgado p. 45
Ryan McGinley p. 65
Inzajeano Latif p. 123

Rather than attack a subject, soft light caresses.

Richard Learoyd uses soft light to create portraits with a deeply meditative quality. In this image, see how the shadows curve around the lines of the body, their edges slowly fading rather than coming to an abrupt stop. This is the work of very soft, or 'diffused' light.

Portrait photographers love soft, diffused light as it draws out form and features without being severe.

Soft light is a master of mediation. It softens any hard edges and smooths surfaces. It's a light that only flatters.

Experiment by placing your subject at different angles to the light. See how the shadows change, giving your subject a greater or lesser sense of three-dimensional form.

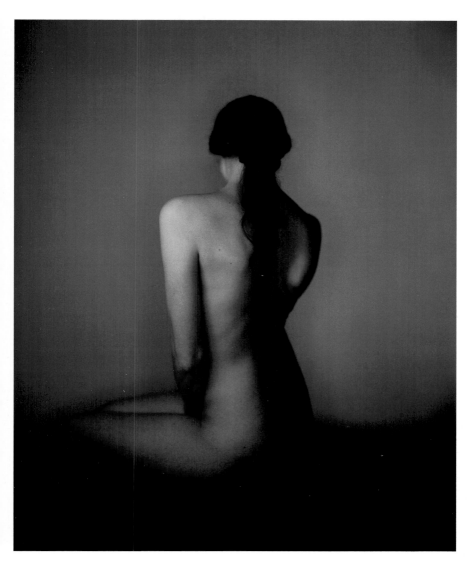

Jemma on Mirror
Richard Learoyd
2010

The connotations of colour

For other examples:
Luca Campigotto p. 38
Denis Darzacq p. 53
Maciej Dakowicz p. 116

Another way to categorize light is by *natural* or *artificial*.

Natural light comes, in one form or another, from the sun. Artificial light comes from manmade sources – anything from household bulbs to street lights to flash.

Natural and artificial light are unequivocally distinct. They convey different moods and are very different in colour.

Here Nadav Kander photographs an anonymous house overshadowed by a monolithic overpass. See how the sodium glow of the street lights has drowned out the natural light and cast a yellowish hue over the image. This creates a sense of unease. It makes the scene feel so unnatural, almost polluted.

For a very different kind of light look back to the photograph by Tom Hunter at the start of this chapter. It shows a woman reading a possession order in the light of a window. The natural light gently touches the woman, the letter and her baby. Its colour is so 'white', it creates a state of innocent calm.

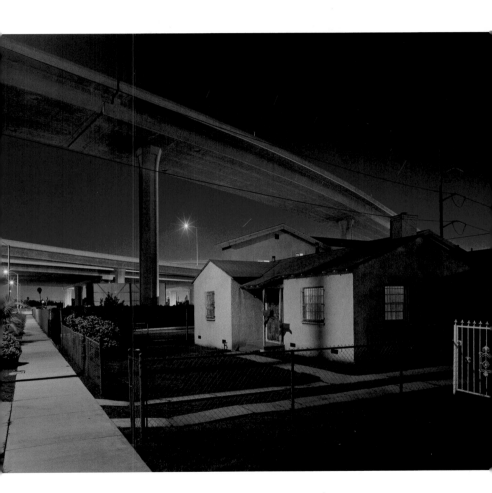

House under Highway,
Los Angeles
Nadav Kander
2005

Controlling colour

Light comes in all sorts of different colours. Daylight can be quite blue, or cool, while household lights can be quite orange, or warm.

Adjusting your white balance allows you to either accentuate the colour of the light or make it seem more neutral, or 'white'. This is important when it comes to conveying a particular mood or atmosphere in your image. So, for your shooting convenience, your camera comes with a few white balance presets, which match some of the most commonly encountered lighting conditions:

Tungsten
Incandescent

Fluorescent

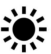

Noon
Daylight

Flash

Cloudy

Shade

Each of these symbols represents a particular colour (or temperature) of light. By selecting the symbol that best matches your shooting conditions, the colours in your image will look truer to life.

To get a feel for this, shoot the same subject using different white balance settings and you'll see how the colours change.

As Nadav Kander has shown on the previous double-page, an image that looks 'too blue' or 'too orange', for example, isn't necessarily a bad thing. You can use the colour of light to provoke an emotional response in the viewer. Giving your image a slightly blue cast makes it feel cooler. Giving it an orange cast makes it feel warmer.

Don't get too hung up on perfecting white balance, because setting your camera to 'Auto WB' (**AWB**) generally does a pretty good job. It's only in extreme cases that you need to change it yourself.

The light without love

A woman runs down a debris-strewn alleyway barefoot and wearing nothing but a white nightgown. The camera angle is low; the frame skewed. This drama is arrested in the violent light of Daido Moriyama's flash, which reaches out for the woman like the frenzied grasp of a psychopath.

Inbuilt flash dominates the look and feel of an image.

As the flash lights your subject from the same angle as the one you're shooting from, harsh shadows are thrown forward and its intensity causes anything in the very foreground, or slightly reflective, to become overexposed.

The use of inbuilt flash dowses Moriyama's image with an unsettling yet mesmerizing fear. But, if used less skillfully, it can also work against you and create a snapshot look that is wholly unflattering on a subject, so proceed with caution.

Shooting in **P** (on most cameras) or 'Shutter' or 'Aperture Priority' (on all cameras) means your flash won't fire. Alternatively all cameras have the option to turn off the flash (⚡). If it's dark, you could increase your ISO instead (need a reminder? See p.50).

Untitled (woman in white dress
running in Yokosuka)
Daido Moriyama
1971

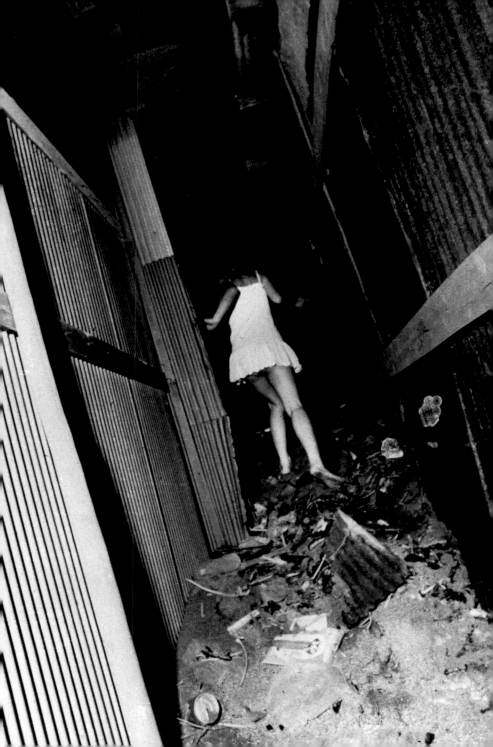

Daylight flasher

For other examples:
Martin Parr p. 18
Philip-Lorca diCorcia p. 91

This model's speciality must be swimsuits rather than hands if she's willing to offer up her finger to a passing seagull like that.

The reason this shot looks so 'electric' is because Elaine Constantine has used flash in daylight or 'fill flash'. Here, it's made the foreground subject stand out and given the shot amazing energy.

To force your flash to fire find the button or menu icons marked by ⚡ and scroll through the options.

If you're shooting a backlit scene or just want to make your subject stand out even though it's not necessarily dark, fill flash will do the job. But fill flash is an artificial light source so it won't give your image a natural look.

On a side note, when a flash fires it throws light on a subject that comes and goes in an instant. This causes any movement within the reach of the flash to be frozen. So what we're looking at here is the result of the flash, rather than a very fast shutter speed.

Now go out and practise

Seagull and Chips

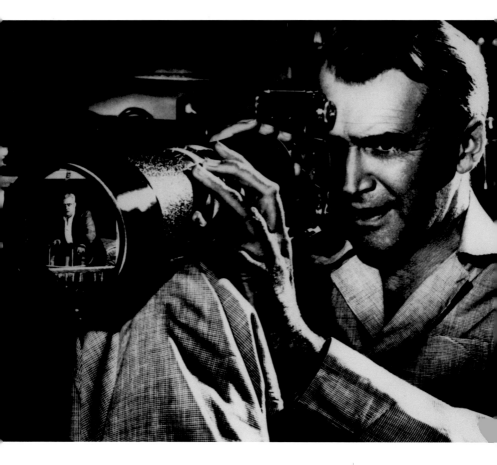

Rear Window film still
**Alfred Hitchcock /
Robert Burks**
1954

Life through a lens

Lenses do more than simply make something look closer or further away.

They radically alter your relationship with your subject and the way you take pictures.

Watch Hitchcock's *Rear Window* and you'll see what I mean. An injured press photographer finds himself confined to his apartment and seduced by the power of a telephoto lens. From his wheelchair, he gains access to the outside world through the lens, but only as an observer, obsessed with spying on his unsuspecting neighbours from afar.

Depending on its weight, a lens can make you more mobile or slow you down. Depending on its size, a lens can make you highly visible or totally discreet. Depending on its magnification, a lens can turn you into an active participant or a distant voyeur.

Each of these qualities has its advantages and disadvantages. And, as we're about to see, lenses can also distort the sense of space in a photograph and change its emphasis. But, more importantly, lenses affect what you're actually able to photograph, as different subjects call for different types of lenses.

This chapter is going to help you understand some fundamental visual effects of different lenses. But first, let's get to the bottom of some essential lens lingo that will see you through even the most gruelling of camera-club conversations.

Lens lingo

ZOOM AND PRIME

Lenses can be split into two types. There are ones which allow you to zoom in and out – you guessed it: zoom lenses. And there are ones that don't. These are called 'prime' or 'fixed' lenses as they are fixed at one particular focal length.

FOCAL LENGTH

This is measured in millimetres. Put simply, focal lengths are either 'short' or 'long'. Shorter focal lengths give a wide-angle effect which makes objects seem further away. Longer focal lengths give a telephoto effect which makes objects seem closer.

FIELD OF VIEW

This refers to how much of the world you can see through the lens. Wide-angle lenses (shorter focal lengths) offer a wider field of view. Telephoto lenses (longer focal lengths) offer a narrower field of view.

Short focal length
Wide field of view

Long focal length
Narrow field of view

SENSOR SIZE

Focal lengths do different things on different cameras.
For example, a focal length that's considered wide on
one camera might seem quite telephoto on another.
This is down to the varied size of camera sensors now
available. If you want to know more about this, I would
go online, but prepare yourself for a lot of technical talk.

Knowing the ins and outs of why sensor size affects focal
length won't help you take better pictures (but it will
help you make friends and influence people at your local
camera club). That said, it is helpful to have a good idea
of which focal lengths give which effects on your own
camera, so here's a table for you to refer back to during
this chapter.

LENS	SENSOR TYPE		
	FULL FRAME	APS-C	FOUR THIRDS
WIDE ANGLE	<35mm	<24mm	<18mm
STANDARD	50mm	30mm	25mm
TELEPHOTO	>70mm	>50mm	>40mm

It's all about the context

For other examples:
Cristina Garcia Rodero p. 15
Melanie Einzig p. 103

Holly Andres's set-up images linger somewhere between memory and make-believe. In this image see how the wide-angle lens presents us with an unusually expansive view. This has allowed more elements to be included in the composition, which, in turn, starts to piece together a story – albeit an ambiguous one.

Wide-angle lenses (or short focal lengths) cause periphery details to play an all-important role.

First the wide angle suggests that the viewer is in the boot of a car, like the victim of a deal gone bad. Then the shop front, the lampposts and telegraph poles all hint that this is a quick stop en route to a more final destination. And then there's the couple. Shorter focal lengths seemingly elongate distance. This has made the woman in the background appear so small compared to that unnerving hand, which looms large in the very foreground.

When shooting with a short focal length, always keep an eye on what's happening around your actual subject, as this context will be an important part of your image. Also, make sure you get close to your subject as shorter focal lengths make everything seem much further away.

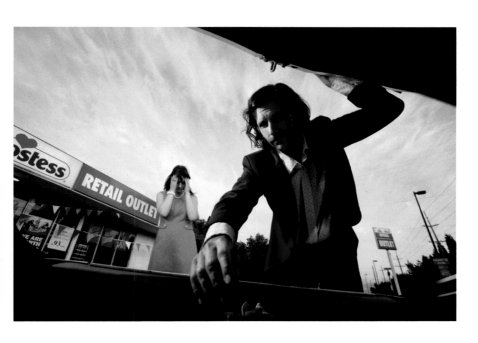

Wonder from 'Full of Grace'
Holly Andres
2009

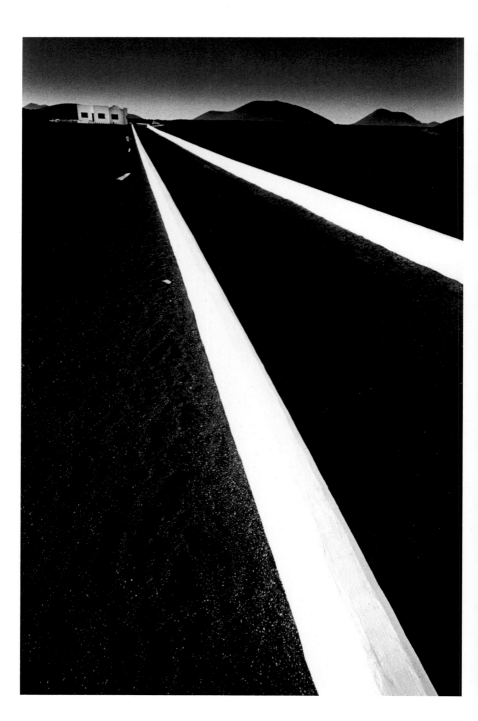

Composition is the key

Wide-angle lenses are often used for landscapes, as they allow you to capture big vistas. But there's a flipside. As shorter focal lengths elongate distance, points of interest that may seem relatively close with the naked eye, suddenly become insignificant details, lost within a wider composition.

As wide-angle lenses create a lot of space in an image, you really have to nail your composition.

Here Jeanloup Sieff has used a very short focal length to created a dramatic sense of space. Notice how your eyes run up and down those lines, pulling you back and forth, from the foreground into the distance, like a visual tug of war. Without such a powerful compositional device the house and distant mountains would have struggled to attract our attention.

When shooting landscapes (or anything for that matter) with a wide-angle lens, look for leading lines and foreground interest. This will help to emphasize focal points and pull your composition together.

Lanzarote
Jeanloup Sieff
1975

Are you a predator?

For other examples:
René Burri p. 93

Telephoto lenses (or long focal lengths) reduce the risk of you getting eaten, scorched, washed away, hit by stray balls or sued. All because they make distant subjects appear closer. But there's more to telephoto lenses than that.

Telephoto lenses transform you into a hidden observer – someone who is suddenly able to capture subjects unawares.

For his series 'Heads', Philip-Lorca diCorcia set up a photographic trap using a telephoto lens and an off-camera flash. When people walked into frame diCorcia shot the picture from afar, capturing his subjects as they walked down the street. The results are candid portraits of everyday people that take on a strangely filmic quality.

Telephoto lenses are essential when you're unable to get physically close to your subject – in sports and wildlife photography for instance. But when you are able to get close, and choose not to, your images can start to feel quite predatory.

That didn't bother diCorcia. In fact, that's what he wanted. But is this what you want? If not, use a shorter focal length that forces you to get in close and interact with your subject.

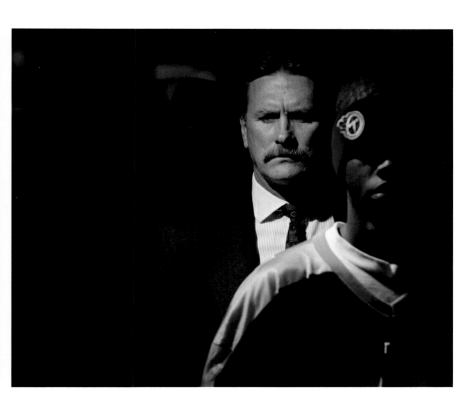

Head #6
Philip-Lorca diCorcia
2001

The telephoto effect

For other examples:
Philip-Lorca diCorcia p. 91

Here René Burri uses a telephoto lens to capture a group of men engaged in a kind of *Ocean's Eleven* walk on top of a São Paulo skyscraper. Whatever the reason for their meeting, up here, no one risks being overheard.

This kind of shot is only possible with a telephoto lens, as the high magnification allows you to home in on small details from a much bigger scene. If shot using a shorter focal length, then these men would be an insignificant detail within a sprawling cityscape.

The telephoto lens causes something else to happen too. Notice how the space or depth in this image feels somehow odd.

Telephoto lenses give the illusion of compressing depth, making everything seem 'flatter'.

See how prominent that long avenue is within the composition. Rather than leading us into the distance, it appears like a flat, vertical strip running up the image. And look at the angles of the buildings, they seem more like layered cut-out shapes than three-dimensional objects.

This apparent flatness is a signature effect of a telephoto lens and it causes images to look more graphic.

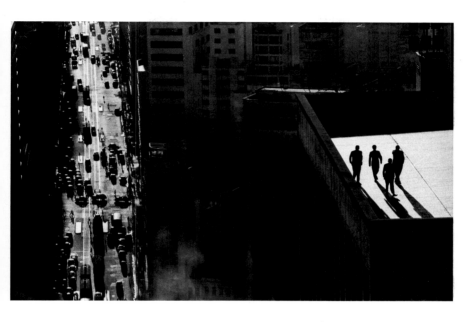

São Paulo, Brazil
René Burri
1960

Far from the standard treatment

Lying between short and long is a magical focal length disparagingly referred to as 'standard'. In other words, it feels neither too wide nor too telephoto.

For her series 'Pull Back the Shade', Muzi Quawson documented the life of Amanda, a local musician in search of the hippy ideal in upstate New York. But rather than photograph Amanda every now and then, Quawson literally moved in with her, sometimes for months at a time, and documented every aspect of her life.

A 'standard' focal length gets you close to your subject, without being too close.

Using this standard focal length allowed Quawson to document her subject's life without becoming intrusive. The results are incredibly intimate photographs, which are also extraordinarily candid.

When deciding on which focal length to use, think about how this will affect your physical position in relation to your subject, and how that then affects the way people will 'read' your images.

Here, a wider lens would have forced Quawson to get physically closer to achieve this level of intimacy, but that would have been too invasive. A telephoto, on the other hand, would have forced her to keep her distance, but that would have felt predatory.

Quawson's preferred lens is a prime: one with no zoom capability. She's not alone in this regard, and for good reason...

Top: *Inside the Bluehouse*
Bottom: *Union City Blues*
from 'Pull Back the Shade'
Muzi Quawson
2002–06

From 'I'm Koo'
Youngjun Koo
2013

Prime examples

Youngjun Koo's website (koo.im) featuring his distinctively clean, fresh portraits of nattily dressed fashionistas on the street has become a Mecca among fashion blogs.

Koo uses a prime lens – one fixed at a specific focal length with no zoom capability. You might think that sounds limiting but primes carry real advantages.

Prime lenses offer wider maximum apertures, giving a much shallower depth of field.

Here, the shallow depth of field causes the subjects to really come forward against a soft background. Our attention is drawn to the people and their clothes instead of the urban busyness surrounding them. And what's the other payoff of wider apertures? You've got it: faster shutter speeds. That's always handy, especially in low light.

All this and the fact that they're often cheaper, optically superior and lighter than their zooming counterparts make prime lenses altogether great. So if you want to get the 'Koo look' use a prime lens. One with a fairly standard focal length will fit like a glove.

For other examples:
Alkan Hassan p. 21
Sebastião Salgado p. 45
Muzi Quawson p. 95
Shikhei Goh p. 98

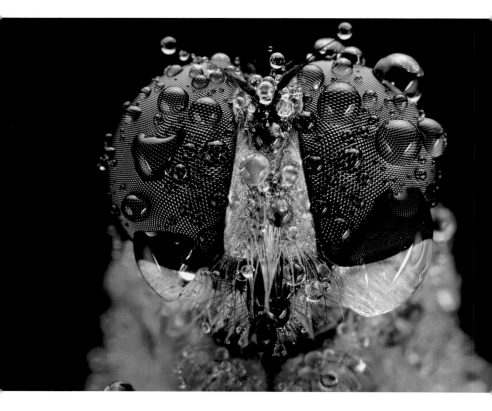

Dew on Me
Shikhei Goh
2012

Close encounters of the macro kind

Macro photography – the art of photographing extreme close-ups – has the ability to transform everyday objects into alien forms and totally change our perception of the world around us.

For other examples:
Edward Weston p. 108

The most common macro lenses tend to be telephoto primes.

As they are prime, the optical clarity is fantastic, while the high magnification means you don't need to be quite as physically close to your little subject as you might think.

Here Shikhei Goh trains his lens on a giant set of bug eyes covered in droplets of water. By doing so he makes visible the amazingly complex patterns and textures of the insect's eyes, which most of us have never been confronted with before. This macro effect gives the bug a monumental presence, like one of the cast from *Honey, I Shrunk the Kids*.

Even though you're working on such a small scale, all the same compositional techniques apply. Here Goh has used symmetry to create balance. Also, notice how the shallow depth of field creates a nice three-dimensional effect and draws our attention to specific details.

Now go out and practise

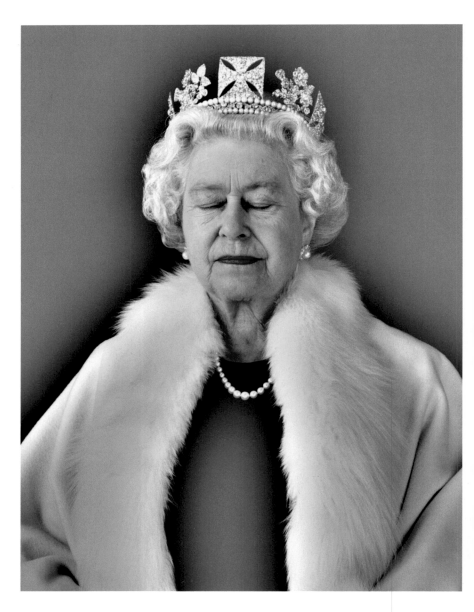

The Lightness of Being
Chris Levine
2004

Don't look. See.

So you've got a handle on the technical stuff. You've got a good idea about composition. Light and lenses too. So how do you use all that to take great pictures?

Well, this is where you go out and practise. Give it a go yourself. Take pictures. Embrace the mistakes and try again. But mastering techniques alone will only get you so far.

If you want to take great pictures, ones that really stand out from the crowd, you need to stop looking and start *seeing*.

Seeing is how Chris Levine captured this portrait of Queen Elizabeth. Originally commissioned to create a three-dimensional, holographic image using state-of-the-art technology, Levine saw something unexpected when the Queen rested her eyes between set-ups. For a brief moment, he was no longer *looking* at the Queen, he was *seeing* Elizabeth.

Unfortunately your camera doesn't have a *seeing* mode. In fact, it can't help you with this at all. That's because *seeing* is very personal. Everyone sees things differently – what's fascinating to one person is banal to the next. *Seeing* is about turning on your eyes and turning off your brain. It's about responding to your instincts.

So what we have here aren't techniques. They're not hard and fast rules. Instead, they're much more about personal approaches, feeling (sorry, there's that word again) and rethinking what your idea of 'good photography' might be.

It's all in the timing

For other examples:
Henri Cartier-Bresson p. 11
Marc Asnin p. 13
Cristina Garcia Rodero p. 15
Maciej Dakowicz p. 116

A man walks into frame with a cockatoo perched on his shoulder. A Rottweiler on the prowl glances to the right. A couple embrace and a character seemingly exhausted by life slumps in the middle of the frame. What kind of strange New York allegory is this?

Here, Melanie Einzig captures four very separate, unrelated 'elements' as they come together for a single moment. A second later and this beautifully odd quartet would have moved on, never to meet again.

Knowing exactly when to press the shutter is one of the single most important aspects of photography. It's what Henri Cartier-Bresson called the 'decisive moment' – arresting photographic instances so fleeting, they come and go in the click of a finger and hopefully a camera's shutter.

Capturing the decisive moment, whether it's a sudden change in the light, a telling gesture or a street scene like this is all about anticipation and instinct.

If you keep your eyes peeled, you'll soon start to see moments like this all around you. When it comes to it, you'll have no time to think, so set your camera up in advance. You want to freeze a moment in time, so use 'Shutter Priority' and a fast shutter speed.

This is about as pure as photography gets.

Spring Corner, New York
Melanie Einzig
2000

Perfect is often imperfect

Badly composed, blurry and brilliant. The technical flaws in this image of the D-Day landing are what make it so powerful.

In this case, war photographer Robert Capa photographs the event up close, in the thick of the madness. While the soldiers waded ashore with their rifles, Capa did the same, armed only with a couple of cameras. Later, his negatives were accidentally burnt in a darkroom dryer, but, rather than ending up in the bin, the few surviving images found their way into the history books.

With photography, there's always the temptation to strive for perfection and disregard – or worse, delete – anything that falls short. But this desire for perfection can choke your creativity.

Sometimes you can't have it all and it's far better to capture the right moment with the wrong settings, rather than the wrong moment with the right settings.

Capa's 'crappy' images of that day have a rawness that do more than just document the event. They capture what it must have been like to live it.

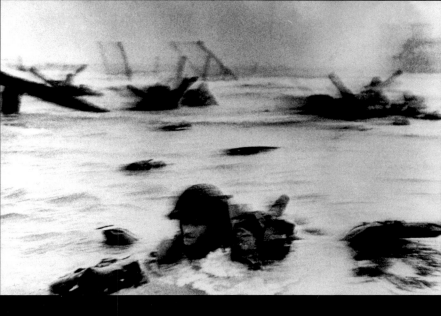

Landing of the American
troops on Omaha Beach.
Normandy, France.
Robert Capa
June 6th, 1944

Don't always look for 'nice'

For other examples:
Lewis Baltz p. 27
Maciej Dakowicz p. 116
Robert Frank p. 121

Where My Grandfather Drank #1 is the simple and poignant title of this image by Stephen J. Morgan.

Beauty. Stories. Visual poetry. They're found in the strangest of places. Morgan found them all in the corner of a run-down social club in Birmingham.

It's with the 'nice' subjects – sunsets, pretty flowers, hot air balloons – that you'll actually struggle to find any of these things. The 'nice' subjects offer you a package deal of conventional beauty. Sure, everyone loves a sunset but your photograph will, at best, only act as a substitute for the real thing.

Average photographers imitate beauty. Great photographers create their own.

See past the obvious and hunt out a more personal and surprising version of beauty. Look for subjects that, for whatever reason, interest you, rather than the ones you think are 'photogenic'.

*Where my Grandfather
Drank #1*
Stephen J. Morgan
2002

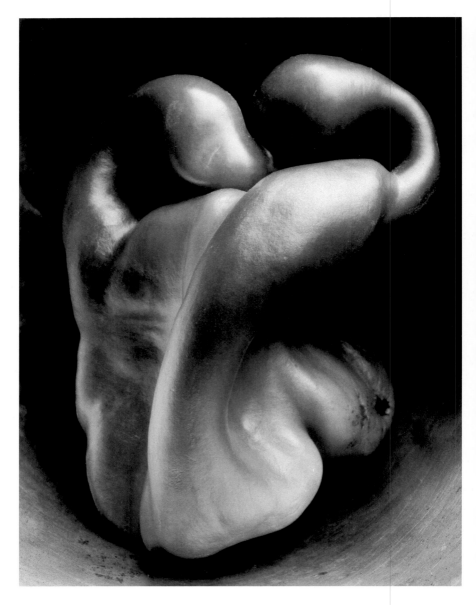

Pepper #30
Edward Weston
1930

See with your eyes, not your camera

American photographer Edward Weston saw the world differently to everyone else. That's what made him one of the all-time masters of photography. But if Weston had spent all his time looking through the lens, rather than *seeing*, this humble pepper would have been eaten long before he transformed it into one of the most famous photographs of the twentieth century.

Great photographs are the result of *seeing* with your eyes. If you're too quick to pick up your camera, you'll risk seeing nothing. In fact, the act of looking through your camera should be the very last piece of the puzzle.

Sometimes, leave the camera in the bag and just spend the day *seeing*.

So what did Edward Weston see in *Pepper #30* that made him want to photograph it? Two figures embracing? The arch of a person's back? A strongman flexing his muscles? Or just a beautifully abstract form in its own right?

More to the point, what do you see in *Pepper #30*?

For other examples:
Lewis Baltz p. 27
Melanie Einzig p. 103

Photography yoga

For other examples:
Henri Cartier-Bresson p. 11
Slinkachu p. 46
Holly Andres p. 87

Spotting the difference between a good photographer and a bad photographer is easy. It's nothing to do with how much equipment they have. It's nothing to do with how much they know. In fact, you can tell the difference without even looking at their pictures.

Good photographers are contortionists.

They're the ones hunching, squatting and bending over backwards. They're the ones constantly down on the ground and climbing on benches. Good photographers perform all manner of photography yoga to get *the shot*.

Here Elliott Erwitt has adopted a dog's-eye view of the world. By getting right down on the ground he's found the perfect angle from which to tell his joke: first we smile in empathy for the small dog in the hat. Then we double take on realizing that those aren't human legs on the left, but the legs of the world's largest dog!

Head height is boring. It's an all too familiar point of view of the world, with a punch pulling neutrality. Always be looking for those unfamiliar and surprising viewpoints, even if it means getting your knees dirty.

To Mr Erwitt I say 'thank you'. I'll happily pay for your dry cleaning.

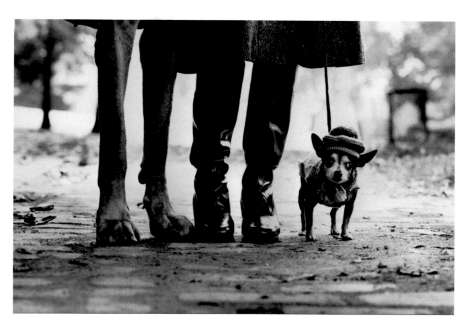

Felix, Gladys and Rover
Elliott Erwitt
1974

Photographs without excuses

For other examples:
Ansel Adams p. 8
Martin Parr p. 18
Robert Capa p. 105

All the effort that went into capturing this shot paid off. The crew of Apollo 17 really nailed it. It's a picture that comes without any excuses.

Great photographs don't usually offer themselves up on a plate. You have to go that extra mile to capture them.

Such images often lie at the end of a patient wait, a steep climb, a long day on your feet or, in this case, a short trip into space.

But nothing's guaranteed. Even after all the effort, sometimes you're left with a shot that doesn't quite cut it. A shot that does come with excuses like, 'just before I took this the light was incredible.' Or, 'yeah, I know, but I was eating my lunch just as it poked its head out the hole.'

Shots with excuses – we've all taken them – require you to be tough with yourself. Just write them off as the ones that got away. Whatever you do, don't let the sole fact that they were hard to get warp your idea of their quality.

NASA picture of the Earth
Apollo 17
1972

True or false: good photographers nail it first time?

Before you answer, take a look at this photograph by Dorothea Lange, taken during the extreme hardships of America's Great Depression.

Just look at that deeply preoccupied gaze. The turned heads of the children. That delicately placed hand and that strong vertical forearm. This image has an intensity that makes it totally compelling.

Migrant Mother is the iconic finale to a few other, not so amazing, photographs. But if Lange hadn't taken those other shots, she'd never have captured this one.

When shooting, give yourself time and keep probing. Often the act of taking pictures leads you to what you're looking for.

Photography isn't about hitting a winner with every click. Getting the shot is a process. Here Lange needed to spend time observing, waiting, shooting – and she didn't stop until she found what she was looking for.

With every shot she edged slowly forward. This built a mutual trust between subject and photographer. In the end, it was this patient, methodical process that made the difference between something *meh* and something magnificent.

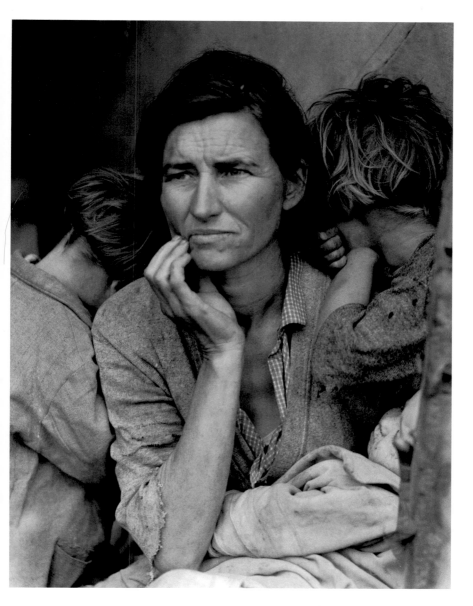

Migrant Mother
Dorothea Lange
1936

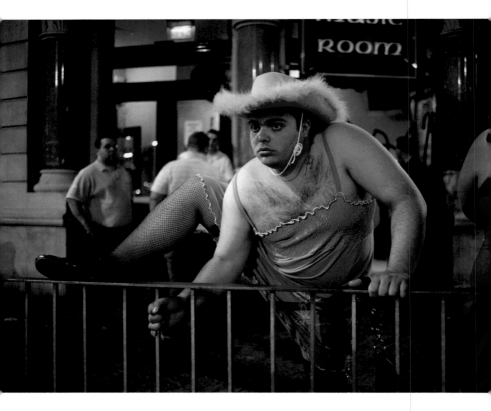

Sunday 25th June 2006, 23:42
from 'Cardiff After Dark'
Maciej Dakowicz
2006

Know what you're looking for

Saturday night. Cardiff town centre. But this isn't an image of a man having 'fun'. It's an image of a man totally spellbound. Of someone far removed from their everyday self. As he attempts to climb over the railings he takes on the appearance of a gorilla escaping from a zoo. Who knows what carnage is about to be wreaked on the world!

Rather than going out with the intention of shooting everything and anything, Maciej Dakowicz shot this picture knowing exactly what he was looking for – inebriated Welsh clubbers out on the town.

For other examples:
Youngjun Koo p. 96

Focusing your attention on a particular subject matter gives you more purpose and better results when shooting.

It can be as simple as saying, 'today I'm going to look for candid street portraits'. Doing this hones your eye and you'll find that you capture moments that you would otherwise have missed or not even have noticed.

By going out week on week with a particular purpose, Dakowicz saw past streets paved with discarded fast-food containers and unconscious teenagers and uncovered a world of vulnerability and aggression, of humour and horror.

Pose questions, not answers

Who sits in this chair? Why has the window been blacked out? There's beauty in those clashing colours and patterns. Did someone consciously bring them together or are they just a random collection of items that occupy the same room?

Alec Soth's photographs of strangers, places and objects that he encounters on the road never quite tell us the whole story. They serve more as glimpses into moments observed and it's left up to us to fill in the blanks.

Don't feel like your photographs have to explain themselves. Hold a little back. Give our imagination somewhere to go.

Here Soth made a choice about what he did and didn't include in his composition. There's no one in this picture, but it's still undeniably a portrait: the magazine, the empty chair, the ruffled carpet and the glowing lamp all add up to something, or someone.

To instil a little intrigue into your pictures don't focus too much on 'the subject'. Instead look for those little truths that start to say so much more. Steer clear of Kodak moments and keep an eye on what's going on in-between. Be a detective and look for the oddities that begin to hint at a story.

Sugar's, Davenport
Alec Soth
2002

Photographs need photographs

For other examples:
Richard Misrach p. 49
Muzi Quawson p. 95
Maciej Dakowicz p. 116

First published in 1958, Robert Frank's *The Americans* is a photography book portraying America as a country of loneliness, insecurity and racial segregation. It takes you on a road trip right into the disconnected heart of 1950s America.

As an art student the photographs confused me. They all seemed a little rough around the edges. They didn't conform to my idea of 'good photography'.

It was two more years before I realized I'd been looking at the *The Americans* all wrong. I'd been seeing the book as individual pictures; analyzing each one separately, trying to fathom why this one or that one was so 'great'.

But *The Americans* isn't meant to be seen that way. It's a photographic novel with a beginning, middle and end. As a series, the pictures suddenly made sense. Together, their style and subject matter carry a message that no single one alone could ever voice.

If you go about capturing individual, unrelated pictures, you'll end up with a nice enough set of photos, but you won't come close to exploring photography's full potential.

By committing to a series – whether it's about a place, a person or whatever interests you – you're able to tell a very carefully constructed story: one where the specific style and order of photographs is essential to their meaning. A story that articulates what you really feel.

THE AMERICANS

Photographs by **ROBERT FRANK** Introduction by **JACK KEROUAC**

STEIDL

Now for the magic

This image by Inzajeano Latif reminds me that photography is a form of magic. It has the ability to do so much more than simply show us what something or someone looks like. Photography – great photography – manages to penetrate the surface of the world and show us a little of what lies beneath.

OK, of course photography isn't magic. What we're looking at here is a skilfully constructed collection of elements. Those clenched fists wrapped in torn fabric. That beautiful light which falls somewhere between hard and soft. The warm orange against that cool blue. And that stare. That confrontational yet vulnerable stare.

But, while all of this is true, the photograph seems to dig a little deeper. Somehow it adds up to more than the sum of its parts.

You could master every photography technique out there. You could have every piece of kit and know all the jargon. But that wouldn't help you capture images like this, as they require an altogether different approach.

So what is it? I asked Latif that very question. He thought for a moment and said,

'Don't overthink things. Photograph what you feel.'

The magic of photography, the bit that can't quite be explained, is you.

Female Boxer #3
Inzajeano Latif
2009

Troubleshooting

Why isn't my camera focusing where I want it to?

Your camera divides the frame into different focusing points. Keep things simple by using 'Single Point' and position this point in the centre of your frame.

Your camera also has different 'Auto Focus' modes. You can either set your focus to track a moving subject – generally called 'Servo' or 'Continuous' – which is good for sports photography. Or you can set your camera to lock the focus when you press the shutter release halfway down. This is called 'One Shot' or 'Single Shot'. This in conjunction with 'Single Point' is the best default set-up. If you don't want your subject in the middle of your picture, focus on it and then recompose without lifting your finger off the button.

Why does my whole picture look 'out of focus'?

Chances are it's not a focusing issue; it's camera shake caused by a slow shutter speed. If you are handholding your camera, check that your shutter speed is not dropping below 1/60. If it is, try increasing your ISO (p. 50–4) or use a tripod (p.39).

Why are my pictures too dark or too bright?

Firstly check your 'Exposure Compensation' (p. 55). Secondly, if you're shooting on 'Shutter' or 'Aperture Priority', make sure that your camera is able to offer you a corresponding exposure value. For example, if you've selected a really fast shutter speed, your camera will need to compensate by using a very wide aperture. You might find that even at the widest aperture still not enough light is entering the camera, meaning your picture is underexposed. In this case, use a slower shutter speed or increase your ISO (p. 50–4) so your camera is more sensitive to light.

Should I use 'Aperture' or 'Shutter Priority'?

Work backwards. Ask yourself, 'what's my picture about?' If it's fundamentally about capturing a moving subject use 'Shutter Priority' (p.34–41). If it's more about controlling your depth of field use 'Aperture Priority' (p.42–9).

What metering mode should I use?

Metering modes change how your camera measures the light. This calculation determines the shutter speed and aperture.

'Evaluative', 'Matrix' or 'Multi-Segment' measures all the light coming through the lens and offers an average. 'Partial' or 'Spot' measures the light from the very centre point of the frame, which can be helpful for backlit subjects. 'Centre-Weighted' is halfway between the two as it measures the light from the central area of your frame.

Rather than mess about with metering modes, set your camera to 'Evaluative', 'Matrix' or 'Multi-Segment' metering. Then use 'Exposure Compensation' if you want to make your subject brighter or darker. This way you start to get a much better feel for light.

Why do the colours in my picture look weird?

More than likely this is because your white balance is not set to the right lighting conditions (p.76–7).

RAW or JPEG?

RAW files carry more information than JPEGs, so if you're going to do some heavy tweaking on your pictures afterwards then shoot RAW. Be warned, unlike JPEGs, RAW files chew up space on your memory card, meaning fewer shots.

Index

Page numbers in **bold** refer to pictures

Credits

pp. 6, 84 Akio Morishima;
p. 8 © The Ansel Adams Publishing Rights Trust;
p. 11 © Henri Cartier-Bresson/Magnum;
p. 13 Courtesy and © Marc Asnin;
p. 15 © Cristina Garcia Rodero/Magnum;
p. 17 Courtesy Toronto Image Works;
p. 18 © Martin Parr/Magnum;
p. 21 © Alkan Hassan;
p. 23 © Guy Bourdin/Art & Commerce;
p. 24 © Lars Tunbjörk; p. 27 Courtesy of George Eastman House, International Museum of Photography and Film. © Lewis Baltz;
p. 29 © Bill Brandt Archive;
pp. 30, 32–4, 42, 54 Melina Hamilton;
p. 37 © Ernst Haas/Getty Images;
p. 38 © Luca Campigotto;
p. 40 © Naoya Hatakeyama/Courtesy L.A. Galerie - Lothar Albrecht, Frankfurt, Germany;
p. 45 © Sebastião Salgado/Amazonas/ NB Pictures;
p. 46 © Slinkachu;
p. 49 © Richard Misrach/Fraenkel Gallery;
p. 53 © Denis Darzacq/L'Agence VU, Paris;
p. 57 Courtesy and © Jo Metson Scott;
p. 59 © Adam Pretty/Getty Images;
p. 60 © Tom Hunter;
p. 63 © Trent Parke/Magnum Photos;
p. 65 © Ryan McGinley;
p. 67 © Fay Godwin/Collections Picture Library;
p. 68 Courtesy of the artist and Luhring Augustine, New York;
p. 71 © Lee Friedlander/Fraenkel Gallery;
p. 73 © Richard Learoyd/Fraenkel Gallery;
p. 75 Courtesy and © Nadav Kander;
p. 79 Daido Moriyama Photo Foundation;
p. 81 © Elaine Constantine/Santucci & Co.;
p. 82 The Kobal Collection/Paramount;
p. 88 © Estate of Jeanloup Sieff;
p. 91 Courtesy the artist and David Zwirner, New York/London;
p. 93 © René Burri/Magnum;
p. 95 © Muzi Quawson;
p. 96 YOUNGJUN KOO/I'M KOO, Street Fashion;
p. 98 © Shikhei Goh;
p. 100 © Chris Levine;
p. 103 © Melanie Einzig;
p. 105 Robert Capa © International Center of Photography/Magnum Photos;
p. 107 © Stephen J. Morgan;
p. 108 © 1981 Center for Creative Photography, Arizona Board of Regents;
p. 111 © Elliott Erwitt/Magnum Photos;
p. 113 Photo by Time Life Pictures/ NASA/Time Life Pictures/Getty Images;
p. 114–5 Library of Congress;
p. 116 © Maciej Dakowicz, from *Cardiff After Dark*, Thames & Hudson, 2012;
p. 119 © Alec Soth/Magnum Photos;
p. 121 Courtesy Steidl Publishers;
p. 123 © Inzajeano Latif.

Acknowledgements

For their generous support and guidance, a big thank you goes to Sophie Wise, Sophie Drysdale, Jo Lightfoot, Peter Kent, Bryony Edmunds, Laurence Richardson, Selwyn Leamy (selwynleamy.com), Simon Tupper (simontupperphotography.co.uk), Cathy Prior, Emily Stein (emilystein.co.uk), Nigel Howlett (nigelhowlett.co.uk), Rishi Sodha and Anton Webb (2creatives.com), Allen George Duck, the tutors at Frui Creative Holidays and Courses (frui.co.uk), all the inspirational photographers featured, and an extra special thank you goes to Melina Hamilton (melinahamilton.com). If you don't like the book, blame them.